ALEPH-BET

An Alphabet for the Perplexed

ALEPH-BET

An Alphabet for the Perplexed

Joshua Cohen & Michael Hafftka

Six Gallery Press
2007

Six Gallery Press
P.O. Box 90145
Pittsburgh PA
15224

www.sixgallerypress.com

In memory of my parents-in-law, Hannah & Joseph Itzhaki, Z"L. Hannah the artist, Joseph the linguist, both resistance fighters & pioneers.

Michael Hafftka, Brooklyn, NY, 2007

To my parents, in memory of their parents: Joseph Cohen & Doris Maier, Agnes Weisz & Bernard Kestenbaum — mere art made them letters and so keeps them; they in their selfless love made me.

Joshua Cohen, Brooklyn, NY, 2007

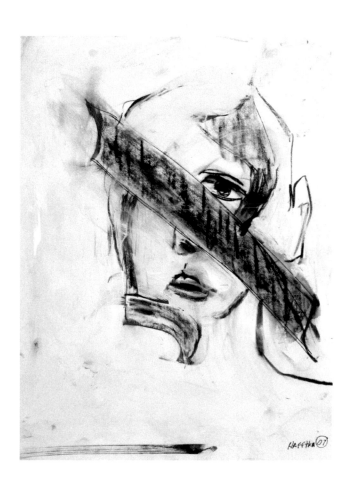

Aleph

NAMING

JOSHUA

If naming is to be called the holiest form of possession, of owning to something, title and deed, then let me be Joshua, the conqueror, the greatest... son of Nun, the payer of bills. A slip of paper is, through the grace of God, or His Russian Super, stuck inside his door in Brooklyn, just above the bottommost hinge, every month, about a week from its turn. An envelope, postage not provided but pread-dressed to a city on Long Island. New Hyde Park, 11040. That's where his landlords live. Or only work. Even Joshua doesn't know. They don't work. They office. I've never been there.

Josh, who as he owns nothing does work, pays the electricity, too, and the gas. Utilities, they're called; they're useful. On the gas, Josh

cooks, when he shouldn't be spending money out to eat. He cooks himself one meal per day, which is lunch late to dinner, the two become one, blurred atop yesterday's plate, old meat in a new mess of sauce. Linner, dunch. Josh eats this meal sitting down at his table, in the unreadable dark, and lately only eats: because once over a rare breakfast Dr. Gottfryd said to Josh it's not good to do anything else while having a meal, especially over breakfast; said in response to Joshua (whom he called Josh, or Yosh, as Dr. Gottfryd's native language, whose pronunciation evolved from the Medieval institution of the ecclesiastical and, earlier, Yahwist "Hallelujah," says "J" as if it's "I" or "Y," its softer, perhaps historically more pliant mouths and ears preferring the Slavic and Germanic /j/ sound to the harder jazz or jalopy of Francophone America), when he was observed reading during bread and cheeses at Dr. Gottfryd's house in Marienbad — a newspaper, whose headline read, in translation of its ink as black as the paper would burn: *Thousands dead in New York…* Josh was told, "It's terrible for the digestion."

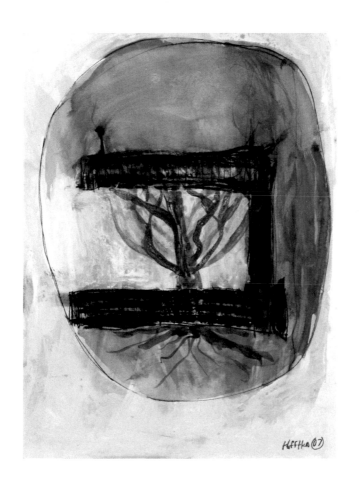

Bet

Joshua takes such advice, "takes things into account…"

When his other friend, Weiner (whose name the friend himself says not Whiner but Weener, as if he's native to Vienna and not of immigrant Hasidic stock), when Weiner says to be there at three pm this Thursday, Josh is there — and at three pm. It is Thursday. And often even ten minutes early. Quarter to. Penn Station. Girls eyelined in worry hold their baggage warm between their legs. Sip ice water, knot sweaters around their waists as if the growth of pubic pelts. Men scurry past, fresh from new business closed, upon six thousand feet. Josh stands under the high sign indicating destination and track number, comparing the clock's time with that of his watch.

I own a watch — I wear it on his wrist.

At night, Josh doesn't eat after dinner, and so he can read. He reads: "And Joshua the son of Nun sent out of Shittim two men to spy secretly, saying, *Go view the land, even Jericho.* And they went, and came into an harlot's house, named Rahab, and lodged there…" which is from Chapter Two of the

Book of Joshua. He reads, later: "And she let them down by a rope through the window, for her house was in the town wall and she dwelt in the wall." And then he seeks the commentary, which is printed in a lesser font, below, and is Rashi's: "*And she let them down by a rope through the window...* By this very rope and window the sinners would ascend to her. She said: 'O Lord of the Universe! With these I have sinned. With these, forgive me.'" Rashi, an acronym fraternizing the title and name of Rabbi Shlomo Yitzchaki of Troyes, France (b. 1040 — d. 1105), is saying, in modern and almost psychological terms, that we are often saved by that with which we are damned. As men waste themselves in harlots' homes with the use of window and rope, so these objects might redeem. As for Josh, he wonders why there's a nail in the ashtray — not a fingernail gnawed, but a sharpness of metal with a battered head. He puts his book aside, checks the clock, then sleeps.

As he often has to wake up early, Joshua always sets an alarm. Again, daily, Josh works, has worked. Has been a cashier, an usher at a movie theater. A musician. A jour-

nalist. None of this was *writing*, especially the journalism... "with a thousand dollars in the bank and six hours left on the clock until the world rings, the telephone with his mother and the kettle" — the newspapers would never let him publish that. And so these minor rabbis known as editors call him, too, offering their own commentaries on his thoughts. He answers his mother with weekend plans: Friday night dinner at the Weiner's, a movie matinéed upon Sunday afternoon; steeps tea. Though at other times, he might make coffee, depending on how his head feels, that and the throat as he's been smoking, again. After a cigarette, and a cup of whichever, Josh goes out into the day, unfed.

Joshua conquered the land of Israel.

But I have been to Israel, and while there worried more about what friends were doing back home than about the sites, the Israeli family and strangers...

As nervous, Joshua is also practical, the doer. The "realist."

As such, he never made it to Jericho.

Though instead of staying at the family kibbutz, he paid for a Tel-Aviv hotel.

Joshua in Hebrew is Yehoshua — *yod, hey, vav, shin, ayin* — though the historical Joshua's original name was Hosea — *hey, vav, shin, ayin* — until Moses took it upon himself to add a letter to it, that initial, fictionalizing *yod* — meaning God.

Hosea means, in Hebrew, "salvation."

He saves — himself. At night, after working afternoons, this is what Joshua does.

As if he were his own-named God.

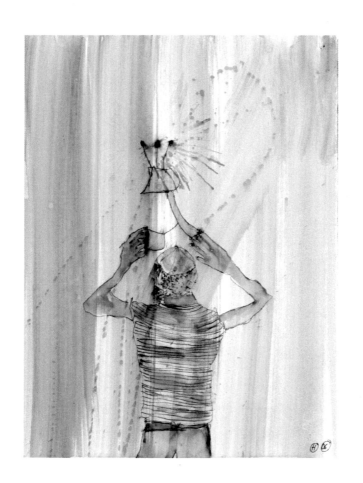

Gimel

JOSEPH

Joseph is a bundle of wheat, a single sheaf with a cap atop. The cap's logo changes with the weather, the weekly dream: once it says "STP," standing for "Scientifically Treated Petroleum," and then it says "Yankees" — at other times, it says in red thread *Grandfather, Pop-pop, Saba, Zeyde...*

His coat of many colors is gray, and made for winter — it doesn't fit.

I am bigger than my grandfather — I have not suffered famine. I have drunk from many milks.

Joseph is a cow that is dreamt neither fat nor skinny... a cow that, no matter how it's dreamt by anyone, itself dreams: a cow that's dreamt its own murder — by my grandfa-

ther's grandfather, perhaps, named Baruch, who had been in Ukraine, which was a ghetto of Kiev, a shochet, a ritual slaughterer. Which might sound worse than butcher, though their work screams all the same. My father was named after the grandfather of my grandfather — Barry. As for the cow above-named, it's dreamt its own murder for centuries — a somnolent violence reified by waking history... imaged under the influence of practical exile — from steady beds, a barn of hay. Its throat is slit, the carcass is cut and the organs are examined; the lungs, brought to the lips, are blown through. No air escapes, and so it's kosher, to be made kosher: the blood's drained, soaked out, salted; the carcass is trabored. Only now, in my own dream, and from it: a steak in the shape of a cow is excised, and is prepared with onion, then served to me by every generation of mother in my family. I am exhorted to eat. That the meat was cut into the cow's shape is thought to encourage my eating — to interest. That rankles me; I fill myself without filling.

Without pleasure.

Joseph was the name of my grandfather, my father's father, whom I never knew. In lieu of this knowledge, I was given his rarely used Hebrew name, but not his American name, which my family used daily, which I do — as he died so near my birth that my father didn't know how he would feel calling me what he had called his father just a short time before.

And so I was named Joshua, after a relative named Yehoshua — what relation, I'm not sure.

My last name is Cohen, which means *priest*. My middle name is that of the first priest of the religion — brother to Moses, who was the first priest of the race.

My middle name is Aaron.

As Joshua, I tell everyone who asks to take my name down for a form, when the census comes around, at the DMV, the Office of the Registrar, *for billing purposes only*: "middle name, Aaron — spelled with two A's..."

But when I am Joseph, in Hebrew, which is a language I half-speak, I am a dreamer — in a language I only half-understand.

Whatever it is that Joseph doesn't know, he doesn't ask to know. Or even want to know, but is ashamed to ask.

Instead, he makes it up. Invents.

But here I will tell everyone the truth about all the lies I've told them — my friends, my family...

How I am happy, despite. How I don't place faith in God anymore. How I no longer keep kosher. How I eat Shabbos dinner among doctors, lawyers, and friends — then drink wine in taxis home with foreign girls.

I won't.

What follows is the true story of Joseph — though it would've been better, or maybe merely modern, if it had been offered to our credulity as dream...

Daled

Rachel's son (my mother's name is Ronnie), firstborn of the favored wife, older brother of Benjamin, second-youngest brother to the other tribal ten, Joseph is in the town of Shechem, where Joshua would later recall the Israelites, they were then called, to the Torah, the Law of the Mosaic God: freed from bondage, created upon pyramidal Sinai from the ruins of enslaving Egypt. He's there, Joseph is, on his father's orders, searching for the flock. But his brothers — they're not in Shechem, and neither is their flock. Probably nothing is in Shechem. Fields upon forlorn field. The desert surrounding, an ossuarial whiteness. The fields themselves, far and wide stretches of grassy laziness interrupted only occasionally by the stones of cult... the stumblingblocks that are, though they are erected to, historical chance. Almost as it looks today, though it's become greater Nablus — already a misgoverned archaeological dig, wasteful and sorry. A nowhere, even in those days caught between two unknowns: between the worship of all Gods, and that of Joseph's greatgrandfather's, Abraham's, Omnipotent One and only. And so a crossroads, say — unmarked and unremarked, as

such. But Joseph has to bring back news to his father, Jacob, Israel — beyond all borders, a report must be made.

This is where Genesis has gotten Joseph. Lost. And suddenly — everything stops. Universal history. Time Itself, with the sun stilled. O the washing machines of New Jersey...

Out of this nowhere, an unnamed man comes up to Joseph. Who is he? Who's this — to be walking amid these fields, and in the middle of such a workaday afternoon (as I've imagined it): idle, seemingly carefree, as if grazing himself? The Ramban, known as Nachmanides, holds he's a species of Angel, in an interpretation abstracted from that of Rashi, who's named names and says he's Gabriel made flesh, but I prefer to think of him as did Ibn Ezra — as a regular man. A mensch, of sorts. An obligance, if I may. And this regular man, this man of the land, he asks what Joseph's looking for. What are you doing in these parts? For what purpose do you sojourn, stranger? Or similar trivia to the same effect. Joseph answers him, asking whether or not the man has seen his brothers

and their flock anywhere around. And the man says that he overheard them say they were going on to nearby Dothan. Joseph thanks the man, and then takes himself off for Dothan, where he finds his brothers, their flock — and our fate.

As if this man had had a toothache, say, that made him stay at home that day, with his wives and their herbal idols, or else, if his youngest wife, his niece, had been unfaithful, and he had to watch her at all times, following her through the marketplace, a shadow at the well... then, Joseph would have never found his brothers, the brothers wouldn't have sold him into slavery; there can be no pit, no traveling salesmen humping their wares in a caravan of camels... no Pharaoh, no Potiphar and so no Potiphar's Wife; then, no Joseph interpreting the dreams of that nonexistent Pharaoh to foretell a coming famine, no subsequent stockpiling of food for when that impossible famine would, inevitably, come to Canaan, too — and so Joseph's family, violating God's commandment to Jacob's father, Isaac ("And the Lord appeared unto him, and said, *Go not down into Egypt; dwell in the land which I shall tell*

thee of…"), would never have come to Egypt, "gone down" and "dwelt"… and so there's no enslavement, no Exodus and then, amid the desert, no Sinai Law. No Joshua. No Canaan conquered as we know it, as Israel greened with honey — as we know ourselves.

As we have conquered our dreams through interpretation — which is thought.

The lesson is a simple one, seemingly drawn here in the sand, as if a straight line between Shechem and Dothan; the moral (because stories once instructed, before they merely entertained, or worse — informed), almost pitiful: a device shameless in its violation, without precedent, this heavy-fisted, strong-armed introduction of such an obviously existenceless man into the sacred field of Law, without name or other local detail, only to serve Whose didactic purpose — a strategy fit for the children we've become…

What am I doing in these parts? With this interloping interlude, this bit of stagy business?

As Joseph, I always ask questions of, and smile at, strangers

Hey

Shabbos Dinner, with Letterforms

ר

A teardrop, cried up near the corner, Is the
corner... a late page turned with its tip a drip
of burnt honey to encourage; last light
scrolled to the spindle of the windowsill, the
threshold, blacked just past the doors, all of
them and those that seem windows, too. A
long and high wall halved by shadow, the
house's torn sheet. Patched with window and
with the openings to hallways, which of
them's what how it's already too dark for
anyone to tell — and from where she's sit-
ting, she's already seated. Up on her heels,
high on a heel, seeking.

This is the form love takes — for my sis-
ter.

My sister, she's often *reduced to this*, or
else: *this is what I've become...* a little blip, a
blob best forgotten — though I shouldn't feel
so terrible about it: she's always been better
at mimicry, of our father, at aping, of our
mother, than anyone else in the family. She
does Mom better than Mom. She is Dad bet-
ter than Dad is Dad, which often isn't diffi-
cult, or doesn't seem to be with how much
he's at home at the office. "Who do you think
I am," ignore her, "What do you take me for,"
leave her alone; you don't have to answer —
but it takes years to realize this, it took me
that long, and then another decade of matu-
rity to become comfortable with silence.

And by that time, I've left the house —
long moved out, moved on.

My sister, what her form asks is the form
of her asking, is what you have to realize:
made small, my little, youngest-only sister.

Though here her smallness, her little or
lessness, seems less inconsequent than vital,
rare. It's been said, she's not afraid of con-
frontation. This is what Mom says and this is
how my sister says it like Mom; this is what
the teachers tell our mother when she's

Vav

desked small herself at the quarterly parent-teacher-conference: your little girl is certainly not afraid of confrontation. Makes mountains out of everything, more of it and hills of salt. Compensatory. To fill with complaint the huge world she's so lost in. My sister spills in the voice or voices of others, which is her innocence, not as much the naïve as the impatient, the willful, *the nerve of these people*... the chutzpah — she knows the word, knows the name of the word, say, but not the name of the language from which the word comes.

With that dark eye of hers, though, she "can get away with anything," and "often does."

More than I ever did.

Though I don't care for getting away with anything, anymore. I'm too old for that. I have my own life, now... how much I've grown in appetite if not in soul.

Anyone can get away with anything if they are, only if they know they are, "unconditionally loved."

My family, sitting at this table, loves itself, loves my sister, more than they love God, and more than they love this Sabbath, though this dinner they're gathered sitting for is meant, if only in idea, in form, to honor that Sabbath, and so to honor its God — and not my sister, who, thanks to her age, which is the youngest overall, is the only one of the family to still believe in God and so in His Sabbath, too, or Hers she says, it's mine. And so, this dinner is cooked and waited upon, weekly, Friday, every Shabbos, if only for her benefit. Not only is she loved more than God, but if not for her, my sister, God would not exist. For my family, if only each fifth day. In short, put littler — my sister is God Itself. As such, in the voice of everyone here, father, brother, mother, she says what she means, always, what everyone means, what everyone wants to say but won't, cannot; as if she needs to, she can't control. She's only a proxy after all, ersatz, a substitute, a logo or representative symbol — a *yod*, an abbreviation of Thy name.

All this, the roof and the sky, a great burden she's bearing, upholding, or only seems to, as if it's nothing, negligible. And then

again, the floor of the diningroom might be uneven. Or else — the ceiling is.

Or both... though differently and floating.

As water has to drip, my sister has to talk, and so does, demands talk in return, her own: a tear with nowhere else to gravity but down, into the very lap of messiness, pitiful, a puddle. It seems, as if every week, every Friday, she's seated directly under this leak — as if through the leak, the sky, the nightly weather, falls to bless her head and, in falling, as falling, becomes her head, too. A cloud's loss, a melt of moon as bitten from the side kept dark just now, tonight. A stain's spreading, this mold's blotch, the ceiling's covering... a remove, a separation: a tempt of the white cloth just laundered, spread out then set beneath her. Her unmarried hair is a brown, near black in how dense and still wet from her earlier shower, the morning's: before school, before the bus drops off, picks up, the waiting at the stop, the sharing of nights' dreams, a drop of black gum on the shoe, on the tongue, before the bowls for breakfast, just after waking in her bed, interiorly designed to lie flush with the full allowance

of the window's light, the length and width of the risen sun. Opening wide her eyes, through the makeup experiments, too much the pimple medicine, straining herself as if it's important, more so than the dinner — it'll wait; ten times urgent, three-pillow necessary, seven books' worth of desired: what she's sitting upon stacked high atop the bottom of her chair, zipper-ripped, fidget-torn of buttons, so as to be the first to spot me in my arrival, she has to be, just has to be, when, finally, to say to me, Josh, which is the name she uses, what took you so long… what's all the lateness for, Joseph, which is the mundane life of my Hebrew name, Yoseph: *yod, vav, samech, fe sofit* — the letters that made my grandfather who died too close to my birth for his name if voiced as mine to sound old enough, and usable.

The black mark a dream makes upon the forehead of the doing day. A chink, a crack. A head thrust forward, through, she's squinting. Boldly.

As if to ask, to answer and both at once, with an enumeration, and so a mocking, of my various excuses: I was late thanks to a

Zayin

problem with the Pontiac; Mister Dago kept me later n'had me do an inventory... after class, after work, which all means: before I left the house and ceased to be accountable; Av and I we were watching this video of something but he had to go all of a sudden, help his mother do something and so I kept on watching the video but when he came back we had to rewind and I watched it all over again because it wasn't the end yet and Av didn't want to see the end before what he'd missed in the middle; traffic on Route 9: a red light had fallen, and'd crushed the dreams of the woman I ended up marrying, my own and this life I've settled for, I'm settling, my own kids and their own personal pets, another life's fire, the sirens of its illness... I was reading a book, is why I'm late. I hope that's fine by you and spiteful. I opened a book and there in the middle of its binding planted a seed of mine and from it, grew a tree. I won't come home until it blossoms that home, with moss for carpeting from its root to the furthest wall that is the sky, and plucked from its highest branch — a fruit for a light dessert.

Whatever reason of mine, regardless, there's always this sense of asking with her: though she knows already, she's daring a denial — a forward thrust, an inclination of the neck. My sister, the inquiry. An alertness is what it is, this taut aspect, spun and wound, how she always seems crimped, coiled, rapt and tightly as if ever-prepared, about to pounce, the mouse we never had except trapped with a snap or else stuck in glue then left for dead in the basement... the pricking parrot, the parakeet-gerbil — to pet, butt or crown me down to the floor and there, half upon the wood, half upon the rug stained and crumbed in a worn aspect or erasure around her chair, to nuzzle me divulged about my day: happenstance since ever the last phone call messaged, the prior news about exchanged. Though it's never enough, she's never satisfied, with even the least, the most excruciating detail, nope. Suspect as to how forthcoming I am, or seem to be. Attentive to even the smallest shed apparently, to her, withheld. How there's no way to respond except with fiction, with fabulation, to invent ever deeper, to gratify with lies. And then what. And then what happened

next. I'll tell you, she will, just let her. A way in which her interest manifests, physically, especially at a new name, whether that of a history teacher she'll have one day, or that of a girl she might hope for a sibling or a friend: who's Sarah, huh, or Sara, uh, how's Lara or Leah or... taunting. An instability in my sister's very form, how she, in her tightness and her littleness, which is her specialty, all hunger and expectation, gross, how she always wants to know, suspecting something greater, something beyond and even, worryingly, unspeakable, maybe, something unable to be said, perhaps; her wanting to know anything at all, and then to know everything about it, too, and all that without a thought for the nature of such knowledge, its appropriateness to the table, its relevance to her and to dinner with the sun gone down, another day. And so her teetering contortion, her high and heely crouch, the very form of her need to always mark off, to designate, to separate — to quote. "You said you'd..." "You promised..." "You..." To hold me against myself, and then to do so even in my own voice, in her imitation of it, in my imitation of her imitation of it, in her imitation of... *save it for later* — she's waiting, they all are.

ו

Upright. My father, unbending, straight and narrow in the knees. Kept all the way to kempt, this late and this long it's almost a miracle, yarmulke pinned down to shoes, with heels together, the weekday wingtips, polished black only this morning, at bed's edge, with 06 blinking 00 upon the clock: how he's managed to maintain immaculacy, tight and zippered and buttoned up to the collar and still with his tie, narrowly knotted, shadowing near — to go with the office clothes, matching the office shoes and voice, are the office words: *evenhanded, aboveboard.* All is safe, secured. Now, he's standing, and swaying lightly, freely, which feels good, it must, this stretching strain, as day's been spent in sitting. Punctilious at his desk,

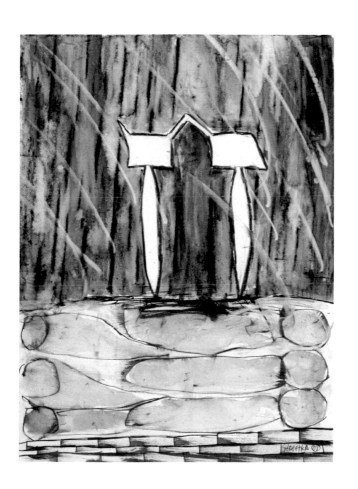

Chet

scrupulous at his lunching and then his desk again, as honorable in his work as in this, its familial leisure: suggestive of the incorruptibility, until me, of his line. Grandfather. Greatgrandfather. Greatgreatgrandfather. The portraits hung in patrimony, their descent all the way down the stairs to the basement, black & white and framed in wood, glassed-over. The storage space. The hot water heater. Multicolored valves, giving access to granaries of insulation. Old toys and clothes grown out of and luggage spared as sarcophagi for bicycle parts. There, the root of my lateness... how I've grown, who I've grown into and the daily dark suits tailored to him, custom, cuffed (is how he always wore his), my wife's name, my wife's mother's name, the metallic color of the car I'm thinking of buying next with the type of wheels least likely to fall off, the best type of nail to use for which hanging job around which household's stair: it's not that he's not interested in any of this, and it's not that he's not uninterested, either, it's only that he Is — as standing, as respectable, reserved, and not out of any masculinity or other fear, but because of how tired, how exhausted he's

maintained, his patience. Only sleep, that's all that perks — it would be too much to stand for anything else. That he's entitled, for now's enough — there's still a lot to bless before the day is over.

Take a closer look, though, incline your ear — a *vav*, or *waw*, it's called.

Despite what would seem, initially, to any guest, tonight uninvited, tonight unarrived, my father's rectitude, him unbending, him unbowed, which might also be interpreted as mere stiff neck, a stubbornness if only muscular, a hardness not as much exercised for at the gym as it's been willed from years of dealing with clients kept waiting and unsecretaried hours of harried callers — his shoulders are, actually, rolled, even rounded; with the phone so long suffered between ear and bone, they're sloped if only slightly, and the head held above inclined a modest measure forward, too — which all might suggest a relation to his daughter's seeking, her curiosity that's all an attempt to lead, to go first, ahead, but is, instead, and Mom knows this, you'd know this by looking at Mom, and by listening to her concern for her husband's

various healths and happiness, only a perpetual shrug, a lifetime's stilled shrug, a congenital defeat despite surroundings. From without, from the sidewalk, the street that, so empty, might as well be an auxiliary sidewalk, though no one in this neighborhood ever much passes, especially now at dinner time and on their own two feet, my father seems only a slight smidge against the windows, stretched deceptively thin and tall in his hide behind or as a middle mullion, with his head and shoulders merged, disappeared into the sky.

Dad's often been credited with being this "pillar of the community..."

A slight stoop upon thin feet. As if he's always peering, himself looking, listening, even if he seems not to be, even if he appears always inattentive, out-of-it — it's purposeful, might be. An equivocation wrapped in drooping socks he likes the warmth of. He might be unsure, but he's never mistaken. Unmoved. Immovable. And swaying, a tiny shiver. That, and his hair won't stay down, and how he refuses to smooth it because such a knifely gesture, and this though after the

dribbling of the candles is before the breaking of the bread, would only go to show those around the table how bald with gray he's becoming, so quickly, too soon. Hereditary, I'm afraid, if human. That and the exhaustion. Or else, it's now that to calm his daughter he sits her on his back, a sistered hump — as if the curling climb of a uniped stray tumor, a cancer cell roaming roguishly toward the head, now perched atop his shoulders as the head, a double-headed, dark-faced hunch; their shadow they cast as long and as dispersing wide as the table and then the floor and then the hall connecting toward the vestibule, is there diffused, at its fringing, front-doorward, scattered into night. Then atop it all, that yarmulke, which he wouldn't have adjusted if she didn't, now — sloping forward, toward the growth's nose, the third and lower eye of his disease. And even as she kicks him, with her heels in the nipples, one's shallow heart, then the black hollowness of the other breast, which is its mortal hunger, still he doesn't move, remains — holding in a hand his cup of wine, filled for the Kiddush, flush to his side, as if, without mind, he'll stuff it down into a pocket of his pants, those

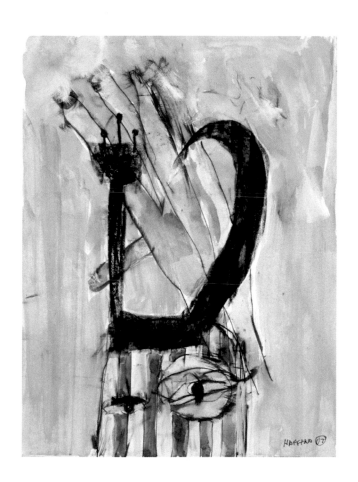

Tet

of the office's suit he hasn't changed out of
yet, and won't.

Seated to my father's left, my mother's right, across from where my sister was, her now perched high, and higher now, as if the inflamed cockscomb of the chicken severed from the body below to be served as dinner, shortly — my brother, his legs and arms widely held and open and yawning. He seems a mouth, mostly, as if that's all there is to him, and so he isn't, mostly: wide and open and yawningly enormous... that and anything else that can be fit down there, into him, as him. Stuffed. He seems a mouth in that he's empty, not absent like I am but empty as in vacant. As in, he doesn't need me much. I want to know my brother better; I wish I did.

I love him, though he is a hole... though he seems a hole to me, he always has: an

emptiness, which sucks up everything, all sense, all love, what not. Not that he consumes. It's that he doesn't, doesn't need much or much want or ever demand. He mouths is what, is mouthed — more than speaking, he makes shapes, gestures, yawns and feints with tongue and gapes. What's inside him, I'm not quite sure, and none of us are or ever were. We used to talk about this, often. How he was born this way: complete, without us. How he seems like a bunch of things and stuffs flung atop a plate that is him, too: a plate heaped high with courses always changing, as he's always changing, always coursing, him growing, maturing, his facial bones bending, his fat spreading and thinning out again then pimpling over and then dry again and matted all with hair, or shaved. A goatee or just a moustache as if sauce dried or food stuck. Rinse him in the sink; put him through the washer, then rack him for the drying. Let the pimples weep and heal around us. The gape remains, the gap. A distance put between. A rift. A disconnect, a void. It's difficult, with none of us quite certain — how and where with love to kiss or hug a circle or a sphere?

We used to talk about this, too, our sister did, would talk to us, for us: how he never much shows his own love. Our sister loves him just as much as I do, but she knows him better, or just says she does; I haven't lived at home in a while.

Not quite a nullity, more like a hollowness: the rim of a person, the shade, the skeleton — with him, they are the person, too. A person dropped to pieces, shattered with the inmost shards unglued. His mouth, his eye, there, now here, now there again the other eye, loose and rolling, rolled: a tongue's table stuck out the side, unclothed, whose woods' grain, each fleshified wrinkle of which, has been stained to the wavelength of a voice I imagine to be his, the voice he uses to say things to himself, to say personal things, to relate privatenesses — vibrations or oscillations in inner sound: the tremble of distant tonsils; the far dangle of a uvula, its meager bunch of one white grape. What would you do if you woke up one morning and all your teeth were gone? What does it mean to have dreamt your own death by choking — and then waking up you're being choked by the two hands of a cartoon orb?

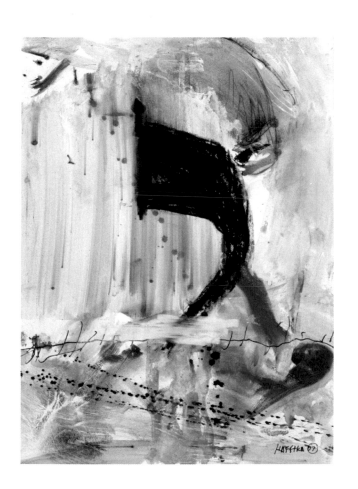

Yod

Late night conversations, when we should have been sleeping: what's the nature of nothingness; where do black holes come from; and where do they go; how deep was the crater that killed the dinosaurs; what made the crater how deep that killed the dinosaurs; what made that that made the crater how deep that killed the dinosaurs who are represented in blue, in white and in red upon his sheets both fitted and flat, which used to be my sheets, handed-down, surviving for yet another night, another's dream. There are sixty bones in the two hands of a priest, a Cohen, and sixty letters in their blessing, making, tucking in. And then, lights-out except in the hallway, which is mutual, as the two of us, Shema and laila tov, are exiled to our separate bedrooms that are divided by the laundry, last week's bed-clothes and pillow covers heaped for Mom. Did you know... that we connected in mystery, that of the facts — it's only meaning that confused us, sundered us apart. Did you know: sleep is one-sixtieth of death; dream, one-sixtieth of prophecy; that the Sabbath is reckoned as one-sixtieth of the world to come?

Eden, that means: a cyclically perfect exis-
tence, inviolable, circumscribed by a river
that is four rivers, tiny silver snakes that
share and never sting. My brother, who
though he came after me seems as if birthed
first, in his silence, or quiet, appearing the
older, wiser even than our father, the very
first, an Adam though that's not his name.
He's sinuous, too. Indirect. Bendable, as
changey. In his soft voice, and in its softer
intention, that of his body's curl, which is his
eye, all both of them, which is his mouth,
each one of his sensing, insensitive, holes —
there's a continuous elongation, or prolonga-
tion, along the lip of his yawn, a hissing
expansion of breath unbelted that's light and
smells faintly of a lunch of round food, any-
thing he can fit in his fist to munch from
while in motion, while being moved by the
time that denatures day with schedule: an
apple; a sandwich, splayed, rolled around
which filling missing, the egg salad, the tuna
fish, solid white albacore in water laid dry
upon two slices of rye with seeds, blessingless
bread whose crusts had been so panicky cut,
our mother, flaked, burnt from the toasting
then brushed away that morning that noth-

ing's left for lunch save the hole that hungers still, the night.

Uncomplaining. Isolate. Negated, yet alone.

Only this: there's that tip, that fray, a single looseness still to speak of. An itch at his armpit, at which he scratches, fingers braiding there, corkscrewy hairs into scented wicks, a wick, as if to make of them another tongue to worry — of yet another mouth of his many, all of them if not silent then merely quiet in their gurgle; as yet other mouths of his shush them, and tsk. All self-involved, self-inquiring. Though always unobtrusively, polite.

A finger of a hand wrapped around with hair that, unlike the two candles burning down, or the hand that will hold the knives and forks and spoons, never sweats.

My mother, is turned away. At the opposite
head of the table, at the foot across from my
father. And there facing the doubly opposite
walls, in-turned, which are that of the hall-
way toward the door, the front. Opposing.
Her head turned atop her body and an arm,
the same arm that on her mother would have
been numbered, the same arm that on her
father would have been tattooed, only if — an
arm the same as her other, which hangs
limply by a hip and with its hands and fingers
clutches at her skirts in an occasional fitting
of nervousness, though in the kitchen,
toward which a foot is pointed (as if the indi-
cating arrow of the scale she'll fail, she
thinks), the food's already all prepared, and
kept warm steadily; the oven is working,

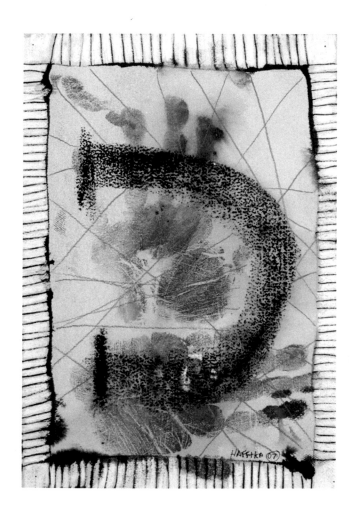

HAFFKE 07

Kaph

there's no leak from the range. She rubs the fabrics of her hem together as if divining, or summoning. One expects smoke from her, or fire. Her other arm — the arm apparent — is hung over the back of her chair, is crooked: like the border between Slovakia and Ukraine, just north of the Hungary where her own mother's from, the lower reach of the Beskids, at the fringe of Ruthenia, which was known as Subcarpathian Rus and, too, as a host of other things not so flattering, under historically different regimes of names that numbered in the many, all of them curvy, treacherously bumped. To shatter the femur's spoke, bringing the cart of the crotch to ruin. A great arm, plump in the fist, thick in the forearm, then skinnier toward the joint, as if withering, though it's only an effect of the light from above as shined from a sconce fixed between the two white moons of smoke detector and that for carbon monoxide: a great stretch, winnowing, wicking... from Imperial Bohemia and its Prague, where her greatgrandfather had attended the rabbinical seminary, then down through Moravia, Silesia, thinning into Slovakia when it was still Czechoslovakia in the year she left, her

mother, my grandmother turned away, on into the Carpathians and further, lost to the darkness.

A narrowing up from the hand, topped with a slight fingery turn — like the way Shore Road goes through the Point, then angles into the circle for the Ninth Street Bridge by the 24-hour diner and the daylight liquor store, to the east, which is irrevocably behind us.

She's facing the same door that her husband is facing with their daughter, generations on, upon his head: the door they expect me through, though now grown I'd ring, though now grown old I'd knock, and though I still have my key, there under the mat below where my shadow would darken the dark, and with the mezuzah, which contains all the letters, above, enjambed; and then between them, down the hall — the door's common glass that holds her reflection, her sitting slouched and turned numbly and strange on her spine, with that arm of hers handing over the back of her chair, impatient, almost wretched. Her frown. A bob. She should have never cut her hair, but her friends did if

she has any friends and not just neighbors, and so she did, and so as theirs is short, hers is, too. It seems she's far away, diminutive, and final: as if the table has opened up its thousandfold foliage, leaves, accommodation ripped out from under, upzoned and sprawling, a great wooden mechanism unfolded upon rusty hinges, stripped screws and languidly warped so as to convex or bow like petals through the pressure of my brother's elbow, Sunday brunches' worth of generous use — seating my mother further, less relatable than ever. Still, there, and in the glass, too, this is her, my mother, that is, in her reflection, un-reversed, a mirror truer than the eight of them upstairs. A woman older than she has to be, who sits uncomfortably, only halfway here, turned away, cheeked as if slapped by a fan blade.

Why not pull the chair out, if not properly then only for effect. Why this discomfort, the cumbersome coccyx twist of the spine displayed, like how she used to wear her hair when young, which was long, and freely frayed, this she'd say through her mouth that's been without lipstick for hours until last hour with her husband home: why this

uncomfortableness, which has one more syllable than a hand has fingers upon which to count them out. With the last one — the nesting "ness" — which is the quality of being, existence's condition palming off adjective to noun, set aside for me, as me, if ever. Though it would've cooled by then, unfilling.

Why so awkward, Mom. I should have called you Ima. You should have asked to be called what it was you desired. And not this guessing, groping, on both of our behalves. How she's pulled, pushed — halved herself: between letting me alone, leaving me, as she has the food, the chicken and the soup with the chicken, and demanding me here and with her, served up, with them, to them... as me, the prodigal son, the dreamer-brother; I can do whichever. Her hand dangles, droops, its fingers flicked with their manicure, which is chipped, bitten wet and soft — the wilt of her arm that's slowly sleeping. Needling once cooked, cleaned then laundered amply, now dead weight, leftover. As if saved up for the week ahead. Extra flesh for the synagogue Sisterhood — that's if she remembers to save herself, bag and then bring with. Blessed Art Thou, Lord our God of the Universe, Who

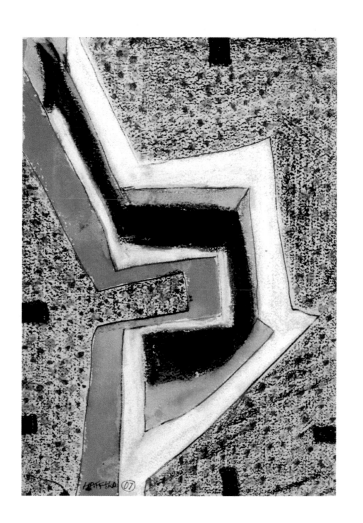

Lamed

Hath Given Us the Meat of our Bodies. Amen, let's say. Her forefinger tapping out the tuneless words, their syllables, contorting — chironomy — to the ecstasies and painful thrashings of their individual letters, to the prayer she'd said not an hour previous, half, the blessing over the candles, that of the brachot still to be said, over the wine, husbanding the Kiddush, the challah bread, and then — they're waiting. Still. Or else, she's ticking off, as if a timer, the kitchen's clock, or that upon the darkness of the oven slash microwave unit, my name. Which is not my name, tonight. Nor that at tomorrow's sunset, which is when Saturday would end even if this Shabbos never does. I don't want that name anymore. I don't need it. I won't make it home again.

A Metaphysical Disquisition

Upon the Nature of the Hebrew *Sophiyot*

I

The Hebrew alphabet has in its possession twenty-two letters, and an enormous quantity of mystical significance has been added on to this sum, though mysticism tends to cloy to every number involved in any way with Hebrew, that most holy, and mathematically misty, of languages — used in Israel to order "fast-food," used in Brooklyn, New York, in my neighborhood, to argue over our imageless God, even while praying to Him for further life in which to conduct future argument. Twenty-two is the number of generations obtaining between Adam, the first man, and Jacob, who should better be known as our Israel. According to Flavius Josephus, in his *Against Apion*, first-century C.E. Jews recognized twenty-two books in the Tanach,

their canon — in what goyim now call *the Bible*: "For we have not an innumerable multitude of books among us," Josephus recounts, "disagreeing from and contradicting one another, but only twenty-two books; which contain the records of all the past times; which are justly believed to be divine [...]" I could go on and on with these incidences, perfectly, twenty-two times, maybe, with twenty-two times twenty-two examples, perhaps — though each one of them would be meaningless, increasingly so... guess how many times so.

But here, amid these twenty-two letters, are to be found five interlopers, five strangers sojourning. This fraternity of five letters gives much trouble to the beginning student of Hebrew. And verily even most native speakers of that language have no idea as to their provenance. The phenomenon of this fivefold fraternity, the *sophiyot*, or final, letters of Hebrew (*soph*, the adjective's noun-root, means "final," or "end"), is the subject of what follows.

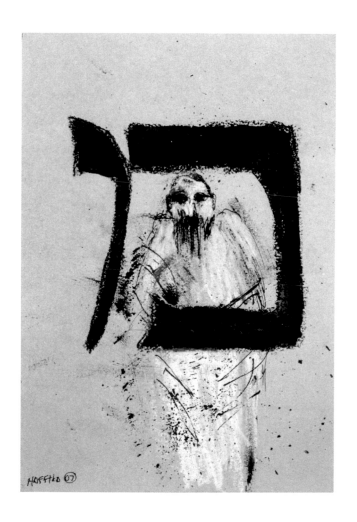

HOFFELD 07

Mem

II

Before we begin, though, a note not intended to read modestly, except as an apology: I am no linguist, nor a scholar of Hebrew, only a writer of stories, of fictions, here seeking the factual story of five letters of a multiform language that's only partially, if finally, mine. Though the following has been gleaned through much reading and thought, it should not be considered as if a perfect account of these letters, nor should it be interpreted as a reliable summary of the various viewpoints of the scholars and texts herein invoked by name or allusion. In poring over such material in research for what I call, almost unbearably, this disquisition, or tractate, I have found, as per Josephus's views on the texts of the Greeks, much disagreement, and much

contradiction. As much as these five final let-
ters are regarded, as subject, as minor, let
what follows be wholly ignored, or only half-
understood. Unlike Josephus, I pretend to lit-
tle authority. Unlike the Author of Genesis, I
prefer to relent before I begin...

III

Linguists and other rare species of God's Creation call the letters that comprise the middle or middles of words, the letters to be found between the first letter and the last letter of any word, by the word "medial." To example, in the word itself, "medial," the medial letters are four: "e," "d," "i" and "a." In this language as much as in the language of God, Israel and Brooklyn, every word is comprised of letters, and every letter occupies as if sovereign and holy ground its own position within each word and of it. But in Hebrew, as in many other Semitic languages whose cultures are rooted geographically and historically far beyond the scope of this disquisition (Arabic letters, for instance, have final forms whose origins arguably differ from the ori-

gins of Hebrew's), there are five medial let-
ters that receive, or accept, final forms. These
letters, then, exist in two letterforms, dual
morphologies: they are written one way if
they begin a word, or if they constitute its
center, and then they are written another way
if they end a word, if they finalize. Presently,
these distinctions evince themselves exclu-
sively when these letters are written; in our
day, but perhaps not historically, as we will
later uncover, no pronunciation is interpreted
as being effected by form. These five Hebrew
letters that take final forms are *kaph*, *mem*,
nun, *pe*, and *tzadik* — if a word ends with
one of these letters, and only one of these five
letters, that instance of that letter is written
differently, in the minority, finally. In the
spirit of the second commandment, as given
to Moses upon Sinai and there written with
its nine others upon two tablets in a fiery
script that read, as we are told, right to left,
left to right and then, too, frontward upon
the face of the tablets and, as well, from
behind... I choose not to image, only to
describe: when written in its final form, a
kaph has its lower line straightened, and
elongated; a *mem*'s leftmost line becomes

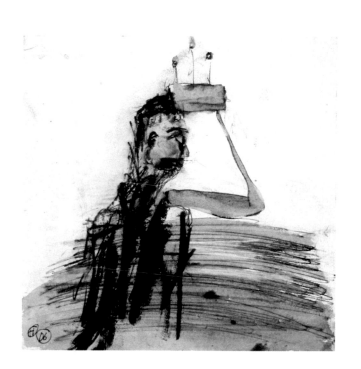

Nun

closed; a *nun*'s lower line, like that of the *kaph*, becomes straightened, and elongated, too; this same mentally dualistic and yet physically unified process, of straightening and of elongation, holds, as much, for the *pe* and for the *tzadik*. If the last letter of a word, of any word — whether it be my Hebrew name, which is *Yoseph*: *yod, vav, samech, **pe sophit**,* or my father's Hebrew name, which is *Baruch*: *bet, resh, vav, **kaph sophit*** — is one of these letters, then that last letter's lower-most line becomes straightened, and becomes elongated... out of practice, out of tradition, the Law. I have thought to propose an acronym suitable to aid in the memorization of these letters, and so here offer the following: KMN — PTZ... *kaph, mem, nun* spelling the word "keymeyn," meaning "to hide away," in the sense of ambushing, or trapping; and then, *pe, tzadik*, spelling the word "patz," meaning "to be dispersed," or "scattered," in the sense of freedom, or deliverance, with a relationship being inferred between a logocentric Exodus and the divinely inspired workings of a "peh" (*pe, hey*), meaning "mouth." Here, the fundamentally metaphysical nature of the *sophiyot* is laid

bare — contradictorily: such a phenomenon, in a search for its origins, both secretes, hides away, even as it releases, disperses. Between the two cardinalities, or directions: between mental and mystical innerness, and physical and historical outerness — even the most dedicated scholar among us might become frustrated, or lost... with his or her very patience becoming, instead, foreshortened, and bent.

Soph — meaning, "the end." Which is the root of the word for its form: *sophit*, or, in the plural, *sophiyot*, the end-forms — not the "final word," as it's said in New York, but even more extreme: the final letter... In Kabbalah, there exists the principle of the *Ein Soph*: the "without end," or "infinite." Or, alternately, "nothingness," the Genesis "void." This term is usually used to describe Creationdom as it existed, or inexisted, before the time, or act, of Creation. Within that waterless darkness, mathematics swirled, sciences smashed up against one another. It is here, boundless and barren amid abstract space, that another explanation, or mystical justification, for the existence of these final forms might be found:

between and within the correspondences of ordinal numbers with the letters of Hebrew, which were first spoken by God Himself upon that very First Day. The Kabbalistic work of *gematria* is the assignation of numerical worth to the letters of the Hebrew alphabet. Though there are twenty-two letters in that alphabet, twenty-seven letters are required to represent each number counting up to the mystical sum of 1000. To explain, from *aleph* on, Hebrew's letters are assigned to the Arabic numerals one through nine (which process requires nine letters); then, from the number ten, the letters are counted by tens up through ninety (again, requiring nine letters); then, at one-hundred, the letters are counted by hundreds up through four-hundred (requiring four letters — for a total of 9+9+4 = 22). The remaining five portions of one hundred required to attain, or to obtain, the sum of nine hundred, before the clock is reset to the first letter, *aleph*, again, and its *eleph* (meaning, in Hebrew, the number "one thousand," and spelled the same as *aleph*, only differently pronounced), are, we are told, represented by the five final forms. When *aleph* is reached, again, we begin a

new word, a new world: *Ein — aleph, yod,*
nun sophit. We, like God, re-begin the cycle
— with the Void...

But just as we haughty, hubristic Moderns
cannot be satisfied with an explanation of
Creation that attributes It all, and even us,
too, to a God and Its Word, we must ask:
what is the actual, historical, scientific, origin
of these *sophiyot*? Why do they exist? Why
has Hebrew, among the most parsimonious,
if not miserly, of languages, developed a form
that can only be thought of, if unexamined,
when unexplained, as excessive, too much?
What does such a phenomenon mean?
Though no "Let there be light" is immediate-
ly shed, there's a murmur. A disquiet's pro-
nounced amid the encampment of scholars.
Disagreements. Arguments reign. Schools are
sundered as if into waters above, and those
below — cleaved like the earth, which was
left to float between the two surfaces. Fathers
stop speaking to sons. There has never been,
to my knowledge, which is slow, and lacking,
any thorough and freely standing examina-
tion of the mystical meaning, or of the repre-
sentational or symbolic nature, of the origins
of these final forms. And so what follows,

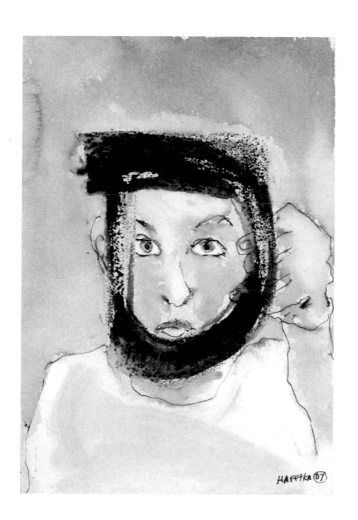

Samech

after a modest and amateur explanation of
the differing, often combative and contradic-
tory theories regarding the practical, histori-
cal roots of this phenomenon, is a hesitant
attempt in that metaphysical direction —
minor, and flawed. As such a definitive and
metaphysical disquisition upon meaning
must, in the end, be written in Hebrew, con-
sider all of the proceeding an examination in
exile — Diasporated from the very language
in which an explanation would best be enact-
ed. Here, in this language — ours will be an
examination both *hidden*, and *scattered*... or
freed. However, before such rare and winged
transformation, or translation, is further
attempted, existence — in a first or original
form — must make its account. In the hopes
of sparing embarrassment (mortification),
which the Talmud says is worse than death,
or mortality, for those scholars and laymen
and women who have been found wanting,
and incorrect, in their analyses of the origins
of these final forms, I will refrain from men-
tioning the provenances of three of the fol-
lowing four theories, which are but a small
and popular sampling of the many, the twen-
ty-two-times-mistaken — imperfect as they

are not twenty-seven, nor five. The truth, finally, and again, is perhaps to be found between them all — cleaved.

IV

PUNCTUATION

Letters become words, and then these words become sentences — these groupings, as they are textual, on-the-page groupings and not phonological, or aural, groupings, which are called phonemes, are to be regarded as artificial, as newer, and are, in the science of linguistics, identified by a host of prodigiously perplexing lexical designates: graphemes, morphemes, sememes... all of them pertaining to meaning, and not to sound's speaking or hearing. This is the origin of one fundamental misnomer: that the *sophiyot* originally arose as a primitive form of punctuation.

In the scrolls of the Torah, so relates this layman's theory, there is no punctuation. Throughout all five books of Moses and then those of the Prophets, too, and those of the

Writings, letters flow into words, and words are separated by spaces, but clauses are not broken, and sentences are unmarked as such. To behold, unrolled, a scroll of the Law is to encounter a semblance of breathlessness, and to confront, too, or to be confronted by, an Abraham's test of one's ignorance. The words that comprise the Bible in Hebrew must be read to be understood, publicly, aloud and thrice weekly: and so one must know the language, in all of its many meanings and melodious tunes, so as to identify and countenance in one's reading all the period phrases, every sentence's clausal breaks, and end stops — necessary to make the text understandable, above the din of the marketplace, amid the surroundings of a congregation of Babel. In other words, only the reader brings punctuation to the Torah, each and every time he or she approaches its presence. It can be said that the chazzan, or cantor, is him or herself a walking, talking comma, or period. A *sophiyot* theory, or interpretation, has been derived from this punctuation-lack: the common misconception that these five final forms of these five medial letters are as a substitute of sorts for such punctuation, as

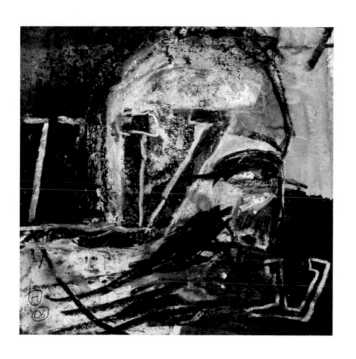

Ayin

if reading guides, indicating, for instance, the end of a word after which one should pause, collect breath. Such amateur thought is, of course, absurd: as its engagingly foolish double-solution — explaining the Torah's punctuation while, at the same time, explaining the purpose of these *sophiyot* — refuses to account for the apparent randomness of these five letters, providing no justification for why it is that only these five letters have these, and specifically these, final forms — as it's not as if words, those of the Torah and, too, those of general, day-to-day Hebrew, end or finalize with one of these five letters more often than they do with any of the other, remnant seventeen. This theory is invalid, then, and should be dismissed, as it cannot, and does not attempt to, account for why these letters have been chosen, exalted above all others, to indicate such practically meaningless pause, or a rest.

PRONUNCIATION

This more educated, or perhaps only more academic, theory holds that the rise of these final forms is a matter of pronunciation, and that their present existence and their historical usage is indicative in differences in the way a letter is sounded, is said, or at least *was sounded*, or *was said*. In the terms of this language, the language in which I write, and the language in which you, sounding, are reading, all Hebrew letters are to be regarded as consonants; at the very least, Hebrew's letters are consonantal, serving an equivalent purpose — with a hardness, a cutting of the breath in their saying, as if the ritual sacrifice of throats, a selfmade slitting of our own air. (What have been termed "vowels" in Hebrew, known as *nekudot*, are a profusion

of various points, dots and dashes, placed above and below and, too, to the sides of the letters, indicating variations in their pronunciation. In the scrolls of the Torah, these vowels, much like punctuation, are absent — as they are a later, Masoretic development, created in Tiberias by Ben Asher around the 10th century C.E. — and so it is up to the informed reader to fill them in for him or herself.)

Before we example this theory regarding the rise of final forms as a matter of the way in which they're to be said, we will first take a look at the exceptional *mem*. Textually, graphically, there are two forms of the *mem*: the medial form, and the final form. *Mem* as a prefix to a Hebrew word means "from" or, otherwise, "than." The prefix translates to either a directional, an identifier, or else a comparison, a cupbearer of difference. If you are coming *m'Jerusalem*, you are coming "from Jerusalem" — and so you are fallen. If you are coming to Jerusalem *m'New York*, you are saved: in an *aliyah*, which is a metaphysical "uprising," a spiritual "going up" that, these days, requires an airplane ticket and passport. Textually, graphically, the final

mem appears closed at its bottom, whereas the medial *mem* is left opened. Mystically, we are told that the two forms of the *mem* represent *Moshe*, or Moses, and *Moshiach*, or the Messiah. To illustrate, to image: Moses is open, and the Messiah is closed, is closing — He finishes, heralds the End. In a score of Semitic languages that predate and gave rise to Hebrew, the paleographic or glyphic letterform of the *mem*, or its diluvian equivalent, is said to represent mayim, or "water" — *mem, yod, **mem sophit***. Moses' "medial" *mem* is connected, or itself mediated, by God, represented by His abbreviation, Yahweh's *yod*, to the final *mem* of the Messiah: signifying, perhaps, that the Law, which is a creation of man, is then attributed to God, only in order for it to later become totalized in the person, or idea, of Messianic redemption. Water, then, might seem if not the beginning of human responsibility (it's said to have been Pharaoh's daughter who plucked Moses from his Nile's basket of bulrush, or papyrus), then at least the origin of a culture of murky attribution, of interpretive currents. And that our only salvation, which is God, lurks hidden between these waters, between those above,

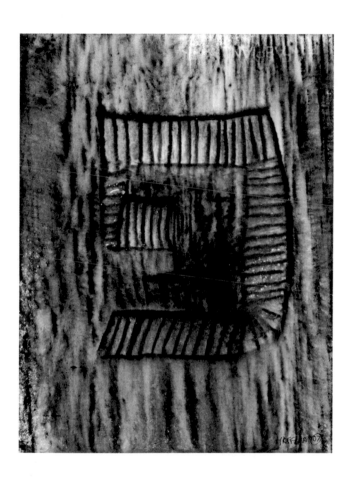

Pe

and those below — between the dialectic waters upon whose surfaces God's very face or facelessness hovered, from every direction, from every dimension, in the timeless time before His separation of them spoke them into becoming both the heaven and the fundament of an unpeopled world.

The way in which this *mayim* is pronounced today, or is supposed to be pronounced, gives no indication of any aural difference between the word's recurrent *mem* letter — offering to present practice no idea of any variance in sound between the two letterforms, leading-medial and final, of what we might term the ideal, conceptual *mem*. The proponents of this pronunciation theory, though, hold that *once there was a variance*: that in Antiquity, the first *mem* sounded, was sounded, differently from the final *mem* — though both can now be regarded as nasal stops, as bilabial nasals, more accurately, which is to say a sound, in this case an "m" sound, produced by means of an obstruction of air in the vocal tract; the lips are sundered, as air is, at the same time, expelled through the nose. This theory explains this phenomenon, of different pronunciations dependant

upon the form of the idealized *mem*, thusly: the *mem*'s "m" sound is consonantally diffi- cult to pronounce, if that lettered sound is to be found within what's been called a conso- nantal "clustering"; in the case of the word *mayim*, the two incidences of the "m" sound might, as if the walls of Joshua's Jericho that tumbled to reveal a conquered Canaan, pile or fall upon one another, and so render the saying of the word for "water" a viscous mess — a salivary problem, perhaps. The same thought should hold for the consonantal clus- ters that can be created by multiple, single- word instances of *kaph, nun, pe* and *tzadik*. To pronounce them, actors and singers, espe- cially (and aren't rabbis and cantors today reduced to just another species of public per- former?), often insert into the word a syllab- ic sound or additional swallowed consonant or vowel, intended to break or cleave apart such a clustering. Such a procedure is known as an epenthesis, from a Latin modification of the Greek *epentithenai*: *epi* meaning "on," *en* meaning "in," and *thesis* meaning "plac- ing" or "putting." Such an epenthesis is often the result of an attempt to naturalize, instinc- tively, a word's pronunciation: an uncon-

scious addition, which process often leads to the usurpation of a word's original pronunciation, especially if the epenthesis in question is an insertion stemming from an incidence of language-borrowing, a foreignism co-opted, to become An or The accepted form of saying said word — an unintended "mistake," becoming codified as general practice. And as this acquisitive phenomenon, itself a super-linguistic, supra-inserted epenthesis of sorts, is accomplished mostly, if not totally, from and through instinct, it's regarded as native to dialects, such as Hebrew, which historically, though not religiously, formed from the shards of a number of Semitic vessel-tongues, long since lost, left for sunken. In the case of *mayim*, this epenthetic insertion, arguably either vowel-like, or merely a breath superadded, is accomplished at, or after, the final *mem* (though technically speaking such an epenthesis situated after the last letter of a word is a phenomenon assimilated into the term "paragoge"). And so *mayim*, slowed in the past, would have sounded more like may — yi — m — vowel-like breath, whether it's to have been the aspirant of an "a," "e" or "o." Another justification for the epenthesis

phenomenon, besides it being the result of a loanword made native, can be found amid an aural analogy with grammar: As a noun is syntactically weak until the appearance of a verb, so, too, any noun's final consonant (and a consonant is, in many ways, noun-like) is weak. It requires, this theory holds, a confirming, or clarifying, sound — a vowel. In Hebrew, the most common epenthetic or paragogical vowel is the vertical, two-dotted *schwa*, meaning, in the form of its root-word (*shin, vav, aleph*), "nothingness," or "falsity," and grammatically speaking an epenthesis indicating in some cases a vowel sound, and in other cases, no vowel at all — only, a contradictory breath... that of exasperation, which is itself a form of rededication — to a task increasingly complex, and bewildering...

Or else, take the letter *kaph*, which is the parental or Godlike relation to another letter, *chaph* — for the purposes of letterform, however, the two are the same letter, with the exception of a single dot in the *kaph*, known as a *dagesh*, meaning "to emphasize," or "stress," which in that very way effects the *kaph*'s pronunciation: making it harder, less guttural — moving it from the rear pew of

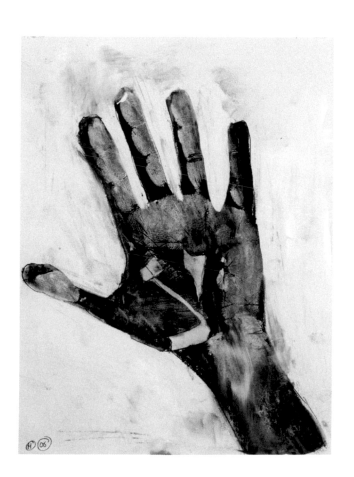

Tzadik

the mouth to the front, or the pulpit; in linguistic convention, converting it from a fricative into a plosive. *Kaph*'s final form, yet another variation on the basic letterform, is actually a pronounced variation not on the *kaph* but on its *chaph*, and so the letter is actually called the final *chaph*, or **chaph sophit**. This instance, proponents of this phonological theory hold, supports the final form as indicative of variance in pronunciation. *Chaph* is, of course, in terms of its modern pronunciation, worldwide and in Israel — throatily, phlegmatically — identical with the pronunciation of the Hebrew alphabet's eighth letter, *chet*; while in terms of letterform, the *chaph* seems almost a *chet* turned on its side. Perhaps, say this theory's scholars, the fricative and guttural *ch* sound (also transliterated *kh*), so difficult for foreigners, in Antiquity was considered so important that it actually had been given three lettered pronunciations (*chet, chaph* AND **chaph sophit**), as opposed to its historical two (*chet* and *chaph*/**chaph sophit**). As the medial letters *chaph* and *chet* today sound interchangeable in much the same way as *chaph*'s medial and final forms themselves sound inter-

changeable, presently identical, one-in-the-same — our throats, as our minds are often accused of, have seemingly, increasingly, narrowed — it occurs to me that one of these letters could almost be done away with, be forgotten, destroyed... if not for the grammar, for the sake of the graphic and these letters' individual, meaningful, functions as text.

In sum, this pronunciation theory holds that the *sophiyot* forms are imbued with epenthetic vowels: open-mouthed pauses, waiting gapes, ensuring exact pronunciation. Fricatively, affricatively, sibilantly and so on — just as final forms are graphically straightened, and graphically elongated, so, too, these epenthetic instances — represented by the existence of these "final forms," created, or evolved, for this very purpose — are aurally straightened, elongated in sound. As the future became the present, and then the ever more distant past, the phonetic or sonic valuation of these final forms was probably lost. Later generations perhaps interpreted the designate letterforms as mere filigree. As stone and clay, wetted, softened, changed over to papyrus as the writing surface of choice for early Semitic texts, a concern for

the calligraphic emerged, among the Arabs, especially: fanciness, and fineness, was the order of the day, and sound hardened into image, remaining unto the ignorance of the present.

THE CHANGE FROM CLAY (OR, EARLIER, STONE) TO PAPYRUS

This theory seems closer to the unapproachable truth, and yet still incomplete, as if unsure of itself — a near-dated, approximately provenanced shard or shred, blown as if only by chance toward the mouth of history's cave... It holds that these final forms originated, across the spectrum of every Semitic or, as the scholars say, proto-Semitic language, with the change from clay to papyrus as the chosen surface of writing. A widely disseminated, though chronologically challenged, school holds the following: that these final forms evolved through, and at, the transition between stone and paper in its earliest surviving form, which is that of Egyptian

papyrus. Here is the argument: Hebrew, which in its most ancient manifestation, not as proto-Semitic but as *Hebrew*, did not have final forms, and was never an entirely stone language; it was never much written, in the second and wider sense of its "final form," upon clay or rock, save for short inscriptions and seals, grave markers, and upon the two tablets of the ten Laws given at Sinai, five of them apportioned for each stone. Hebrew's codification *as Hebrew*, as a language distinct from its Canaanite brethren, or so this theory argues, came about with the widespread use of papyrus, with the engineering of reeds into paper. And so, the development of these final forms of those five letters is purely a calligraphic phenomenon — *caused by that change*, or those changes: the formation and formalization of the Hebrew language, coeval with — tenth century B.C.E., or thereabouts — and related to, the transition from common incision or gashing upon a hard substance to an inscription with ink upon papyri, which process had previously been reserved for the writing of those who held official, and so technological, power: for the words that recorded the deeds and the dreams of the

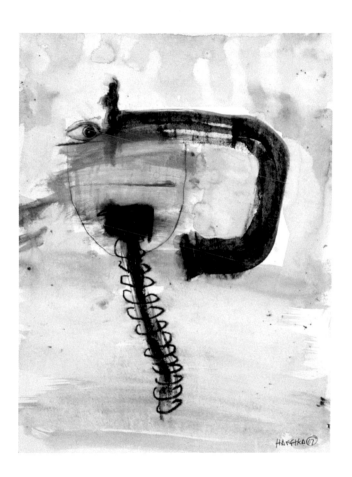

Qof

Pharaohs. Typologically speaking, then, Hebrew letterform — later perfected in the work of the Torah, which is written upon the surface that would later replace papyrus, namely parchment, rendered from animal skins, then stitched together to scroll with their sinew — would evolve with the development of such faster, flat writing: writing with ink on papyrus, on linen or upon human skin (which the Hebrews never did, as per the scriptural proscription), with an implement that turned from a chisel-like stylus to a softer pen made from the stem of a reed (*Juncus maritimus* was often used, as was *Juncus rigidus*; later, in Ptolemaic times, apparently the lowly phragmite was favored). This theory holds that because paper was "faster" to write on than clay, the formation of the words became rushed, and, in the process, corrupted. Though many of these reed stems used as pens had to be chewed on to render them usable, meaning sharp enough, for the act of writing, this theory negates the received wisdom that chewing is a thinking, or ruminative, activity, and instead points to the speed and flat angle of writing to which the papyrus surface gives

rise — as opposed to the laborious carving of clay. One hovers over papyrus, whereas one sits alongside a clay tablet. Letters in stone are squared off, whereas paper absorbs — allows motion, fluidity.

A Generally Unquestioned Answer, Finally – if yet another Error, or Mistake

After all this chronological casuistry, this sophistry with the record, the following answer seems authoritative in its simplicity — and, too, in its mundanity, how daily and negligent it now seems. Often referenced by scholars, and, indeed, the very first answer to which I had been referred in my initial questioning into the nature and origins of the *sophiyot*, I will quote the entire length of its best and briefest summary, which is that of the respected Dr. Joseph Naveh, professor at Hebrew University, Jerusalem, from his landmark *Early History of the Alphabet: An Introduction to West Semitic Epigraphy and*

Paleography (a book most recently "reprinted" — as a digital text: the screen almost finally usurping paper, parchment and vellum, papyrus, sun-baked clay and stone — in the winter this disquisition was written).

Professor Naveh writes:

As we have seen, the Nabataean script evolved from a cursive tradition, whereas the Jewish script developed from the Aramaic book-hand. Both scripts have distinctive final letters. While in the Nabataean script and — especially — its derivative, the Arabic script, almost every letter has different medial and final forms, in the Jewish script there are only five differentiated final forms. Most of the latter are, in fact, the original forms. In the Persian period, *kaf, mem, nun, pe* and *sade*[1] were written with long downstrokes. With time, these downstrokes began to shorten and to curve

[1] By *sade*, Prof. Naveh means what I call *tzadik*. Indeed, this letter, the language's life-giving, life-preserving eighteenth, is the letter most variously transliterated by the language you're reading. I have encountered *cadik, sadik* and *tsadik,* among other spellings. In its earliest Bronze Age glyph form, this letter might have represented a papyrus plant, or a fishing hook: in Hebrew, *tziyed* means "hunt," and in Arabic *tzad* means "to fish" or "to hunt." Many hunt and fish for ways to represent the name of this letter in other alphabets. Few, though, seek *Tzedek* — which is righteousness. As for *kaf*, Prof. Naveh means what I call *kaph*. This footnote is my own.

toward the next letter in the word, eventually evolving into the medial forms. However, at the end of a word, the writer slowed down, and did not curve the downstroke of the last letter, so that the long downstrokes survived in final forms. This applies to four of the Jewish final letters; the story of the fifth letter, *mem*, is only slightly different. The *mem* in the Persian period had two downstrokes, a longer right stroke and a shorter left stroke. As the right downstroke was drawn first, it was bent both in medial and final positions; but the left downstroke curved leftward only in medial position. This led to the development of the medial open *mem* and the final closed *mem* [here Professor Naveh inserts a table, illustrating the development of these five medial and final letters from what he calls "5th century B.C. Aramaic," in which only the "final" forms exist, through the rise of "medial" forms in the "1st century B.C. Jewish," culminating, for now, in "Modern Hebrew" and its use of both forms]. These specific features of the Nabataean and Jewish scripts, and to a lesser degree, of the Palmyrene-Syriac branch, are essentially cursive traits. Since the North and South Mesopotamian script types grew out of the formal Aramaic script employed mainly for stone inscriptions, they have no distinctive medial and final letter forms.

Locating the date for the development of these forms much later than the rise of papyrus (dating their codification to circa the 1st century B.C.E., two centuries after what

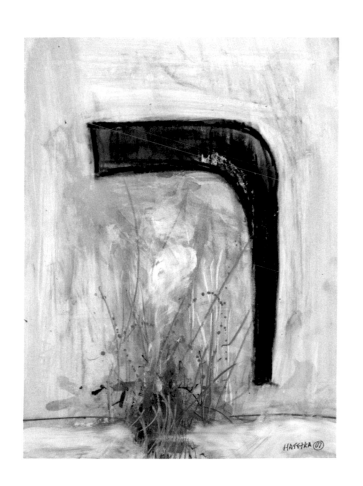

Resh

he calls the Persian period, marked by Cyrus and the decline of Babylon, as opposed to papyrus' Egyptian 10th century B.C.E. — as can be seen, the previously offered theory of the appearance of final forms being coeval with that of papyri is here historically flawed), Professor Naveh is arguing the following: that what we know of as the final letterforms were originally the regular, or medial, letterforms, of the same ideal letters. He argues that, due to the speed, and, perhaps, lightness, of physically writing the letters comprising the middle of a word already mentally thought, their forms became bent — as did tradition. At the end of a word, Professor Naveh holds, the scribe would slow down, and, maybe, press down upon the papyrus or parchment with a heavier hand, as if in preparation for the next word, its writing, its thinking — and so only the last letter of a word would appear as intended, in its true form... *as a letter*: the final letterform, five of them, as we know them today. Only later, long after the reigns of Xerxes and of Artaxerxes, after the preachments of the prophets Ezra and Nehemiah had long ceased to echo, did these forms, coming as they did

at the ends of words, become end-forms, or finalities — in theory, as much as in practice.

But why did this process affect only these five letterforms? On this point, Professor Naveh speaks not a word.

In the preceding, Professor Naveh has used the term "cursive" not to mean the Modern, secondary form of written Hebrew, its rounded, stoop-shouldered "script," today used in Israel for handwriting, its letterforms derived from an admixture of Polish and German (graphomaniacally demotic, or Yiddish) traditions that had developed over the course of last millennium's exile in Europe, but to mean, instead, "written" — as opposed to carved into clay, which, as we're told in Genesis, was the substance of Adam, the first man, or else fired by the forefinger of an anthropomorphized God into stone. As those lesser gods, who are scribes, wrote their cursive upon the face of a slain animal's hide, these "final" forms, according to Professor Naveh, then normative forms, inconspicuously, mistakenly, entered into practice, and in so doing, changed practice, forever. This theory exalts not only the mis-

take, but also the method, the physical —
there's much motion to be found here, both
in Professor Naveh's work and in the actual
history it attempts to describe. While in his
model a scribe is fast to get down onto parch-
ment a word, looping it, in a bookhand
almost connecting, stroke by stroke, each
new "medial" form of these letters, only to
then slow down upon finishing that word,
and now thinking, or else physically prepar-
ing for, the word always next, it's important
to remember, as well, that the actual imple-
ment of writing has changed, that the stylus
has become a reed pen, and that the reed pen
has become, as if already for posterity's sake,
a bird's quill. In this late and still extant peri-
od (*sophrim*, those scribes who write the
scrolls of the Law, forming its letters that
bear their various crowns as if they're the
very kings of their own meanings, still abide
by these olden rules and materials), less pres-
sure is required on the part of the writer,
though there's more busy work to be done
between the formations of letters and words:
and so "Let there be" the rabbis, with their
myriad regulations, the rules of *sophrut*,
which is the work of the "end-user," the final-

ist "fixer," the trade of the *sopher*, or scribe (a condition related to the word *sepher*, or book — in itself an end-form, a fixing of the world between covers). A specific ink, the *dyo*, must first be bled from ingredients: gum arabic, gallnuts, iron sulfate and water; the *kulmus*, or quill, has to be plucked, fashioned from its feather, kept uniformly sharp (its nib must be cut to slope to the left, as Hebrew is written from the right to the left), then dipped wet twice more than regularly... The (meta)physicality of Professor Naveh's theory itself brushes aside all mental categories, effaces them, boldly — imputing such change to the holiest random, the sanctity of dereliction, a lapse that can be called Godlike, and yet still be respected as lapse...

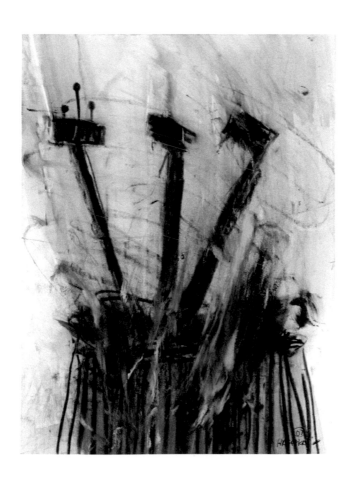

Shin

V

In every theory presented here, the unintended, or unintentional, is evident: in each of them, a change passes uncountenanced, as the unexamined becomes codified — unawares. And so now with the life of the hand — textually, paleographically — or else, interpretation-depending, that of the voice — speaking in terms of the pronunciation of these final forms — usurping that of the mind, we might, to conclude, grope or tongue our ways toward the darkness — oblivion... In such a spirit, I offer the following thoughts — if only for the metaphysical concerns they might illuminate in their passion. As it is said in the Psalms, "The LORD preserveth the simple..." Or else, to excuse myself in the style of the Hasidim of the Baal Shem: *Ich*

bin a narr un ich gleib... "I am a fool, and I believe..."

The only idea common to all of these theories, and so, too, the only idea we can accept, is that the Hebrew language at one point in its history did not have what we now call its "final forms," that they were, for better or worse, and for whatever reason, a later innovation, a development that must postdate the emergence of its initial, possibly unknown and unknowable, morphology and phonology, crawled out from the Canaanite pit or widows' well, shortly after the dawn of our worded world. Additionally, and again, none of these theories adequately explain why such final forms developed, for only five of these letters, and for only these particular five. And so, allow me to suggest that there might have been more "final" forms — whether textually they were originally medial forms, or else, aurally, intended as guides or signposts to appropriate pronunciation — since lost. And allow me to offer this, too, as if a sacrifice to be burnt by scrutiny upon the altar of the reader's belief: that all of the twenty-two letters of the Hebrew alphabet, and, along with them, all of their unfixed,

rootless Jewish sounds, whatever remains, may, in fact, be impure — not false but, as in Baruch Spinoza's definition, fictions, merely the perversion of possible truths. Mistakes. Errors. Which, as that philosopher says, are only the dreams of a waking man — though he seems still reluctant to speculate upon whether or not they might have meaning... as sins — transgressions for which we all should atone.

Finally, this is what interests me most about the minor history of these final forms: its or their consecrated randomness, converted to a condition of chosenness, as if another form of "natural selection" — a mistake, turned into a mitzvah, not just a "good deed," but a commandment, as well. I am fascinated — if in an amateur manner, with all its inexpert enthusiasm — by the way in which lapse, or the lack of deliberation, creates future practice, constitutes life. Here, amid the final forms, is, to me, the horror of Jewishness, the terror of Judaism, is the worst of all observant and organized religion (and so, too, why I myself cannot be "religious," or observant in any traditional sense) — in the most minor microcosm. Though I might be making too

much of such mysticism, a Sinai, say, when a dunghill would suffice, I had my questions — five of them, if you will: why do Hebrew letters have final forms, and why five of them, and why that five; what is their origin and their significance, historically, mystically — and their answer became what is the true, historical and mystical, nature of faith. To end this cycle of questions: Yoseph, my Hebrew name, ends, in Hebrew, in a final letter (*pe*, or *fe*, *sophit*) — and so uncertainly, itself without "closure." In practice, its last letterform is the linger of a pen... a hesitant hover of the mortal forefinger above the magical key that controls, the commanding stroke — the clearing of the throat, the ritual contortion of the tongue, licking itself, wetting its own nib, preparing... waiting on justificatory inspiration, perhaps. Lately, for me, such a lapse as the one I've identified seems a search not for the meaning of what should be said or written next, but instead for the meaning of why there should be anything written or said next at all — when everything's so blemished, so tainted with carelessness and distraction. What does such a metaphysic mean? That given the circumstances,

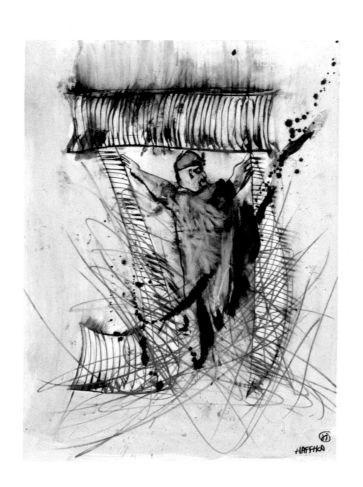

Tav

paleographic and paleopronunciative coincidence, there might have been more final forms since lost, and that all of the letters and their sounds we now know may, in the end, be only corruptions — "final" forms, if originals? What is the point of such speculation? Which is to ask, what is the purpose of language? Of meaning? Would it not be even more final, however, to ask the following, while we still have our inspired senses and breath? — What were those secret originals, these hidden "final" forms? What did they look like? What did they sound like? Could they not, perhaps, constellate the language of a forgotten, or medial, God?

Brooklyn, New York — Pesach, 5767

139

JOSHUA COHEN was born in southern New Jersey in 1980. His books include a collection of stories, *The Quorum*, and a novel, *Cadenza for the Schneidermann Violin Concerto*. Another novel, *A Heaven of Others*, is forthcoming in 2008. As of this writing, he has just completed work on *Graven Imaginings*, a book of the last Jew in the world. Cohen lives in Brooklyn, NY.

MICHAEL HAFFTKA was born in NYC in 1953. His books *Michael Hafftka - Selected Drawings,* 1982, and *Art of Experience - Experience Of Art,* 1981, were published by Guignol Books, Tivoli, NY. *Conscious/Unconscious*, a collection of stories, is published by Six Gallery Press. Hafftka has had one-person shows in New York City since 1982 with Art Galaxy, Rosa Esman Gallery, DiLaurenti Gallery, Mary Ryan Gallery and Aberbach Fine Art. His work has been shown in the US and abroad in numerous museums. Hafftka's work is in the permanent collections of major museums including The Metropolitan Museum of Art, MOMA NY, The National Gallery, Brooklyn Museum, San Francisco MOMA, The Carnegie Museum of Art.

Hafftka's work has been the subject of critical monographs by Sam Hunter, Professor Emeritus of Art History at Princeton University, John Caldwell, Curator at the Carnegie Institute Museum of Art and the San Francisco Museum of Modern Art, and the novelist Michael Brodsky. Hafftka's work can be seen online at www.hafftka.com.

COLOPHON

Titles:: Copperplate Gothic Light by Frederic W. Goudy
Subtitles:: Geometric 231 BT by Rudolph Koch
Paintings:: Ink, watercolor & crayon on paper
Hebrew:: SPTiberian by Jimmy Adair
Design:: Michael & Yonat Hafftka
Text:: Life Roman by W. Bilz
Jewish Star:: Herman Zapf

Made in the USA
Middletown, DE
14 July 2021